Merry Christmas

31 Images to Adorn with Color

Copyright © 2016 by Racehorse Publishing Artwork copyright © 2016 by Shutterstock

Shutterstock/mashabr (Image 1, 2, 4)

Shutterstock/ilonitta (Image 3)

Shutterstock/panki (Images 5, 6, 7, 16, 19)

Shutterstock/Julia Snegireva (Image 8)

Shutterstock/ImHope (Images 9, 10, 11, 12, 13, 14, 15, 21)

Shutterstock/Molesko Studio (Images 17, 18, 20, 22)

Shutterstock/Daria Kubrak (Image 23)

Shutterstock/orangeberry (Image 24)

Shutterstock/miumi (Image 25)

Shutterstock/ARNICA (Image 26)

Shutterstock/snipp (Image 27)

Shutterstock/Nuarevik (Image 28)

Shutterstock/LenLis (Image 29)

Shutterstock/tets (Image 30)

Shutterstock/LiliyaShlapak (Image 31)

All rights reserved. No part of this book may be reproduced in any manner without the express written consent of the publisher, except in the case of brief excerpts in critical reviews or articles. All inquiries should be addressed to Racehorse Publishing, 307 West 36th Street, 11th Floor, New York, NY 10018.

Racehorse Publishing books may be purchased in bulk at special discounts for sales promotion, corporate gifts, fund-raising, or educational purposes. Special editions can also be created to specifications. For details, contact the Special Sales Department, Skyhorse Publishing, 307 West 36th Street, 11th Floor, New York, NY 10018 or info@skyhorsepublishing.com.

Racehorse Publishing™ is a pending trademark of Skyhorse Publishing, Inc.®, a Delaware corporation.

Visit our website at www.skyhorsepublishing.com.

10987654321

Cover artwork credit: Shutterstock/Molesko Studio

ISBN: 978-1-944686-92-5

Printed in the United States of America

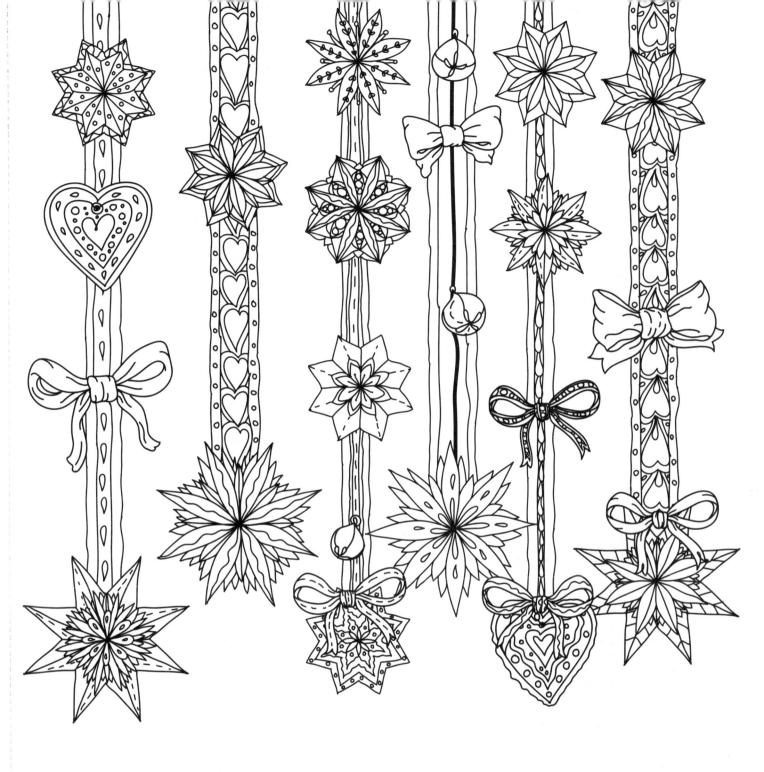

← 1

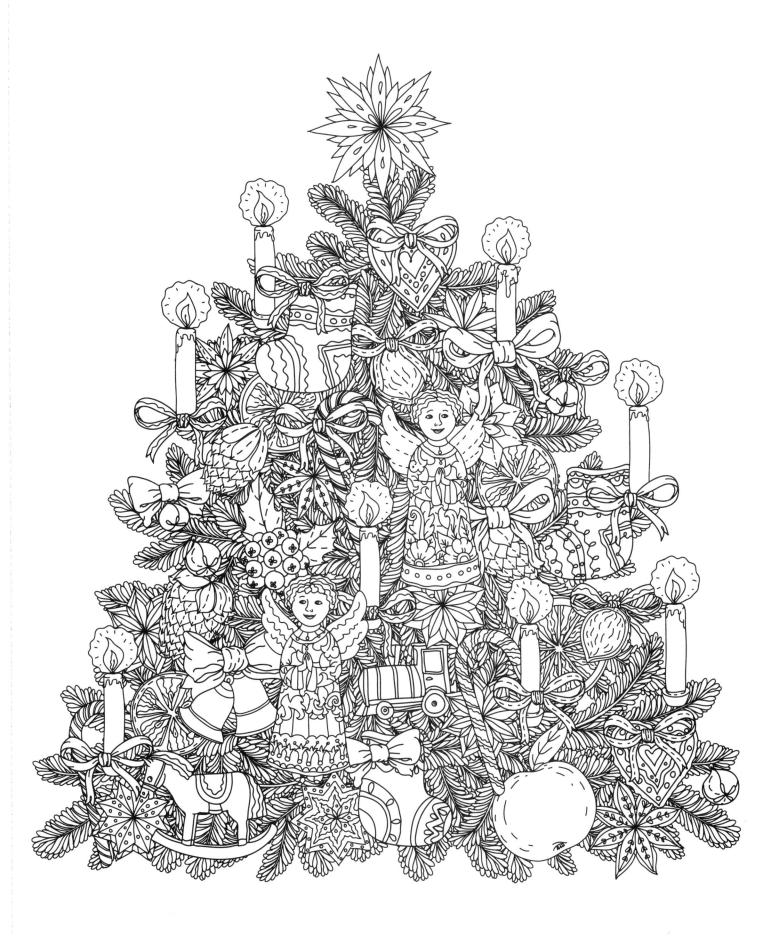

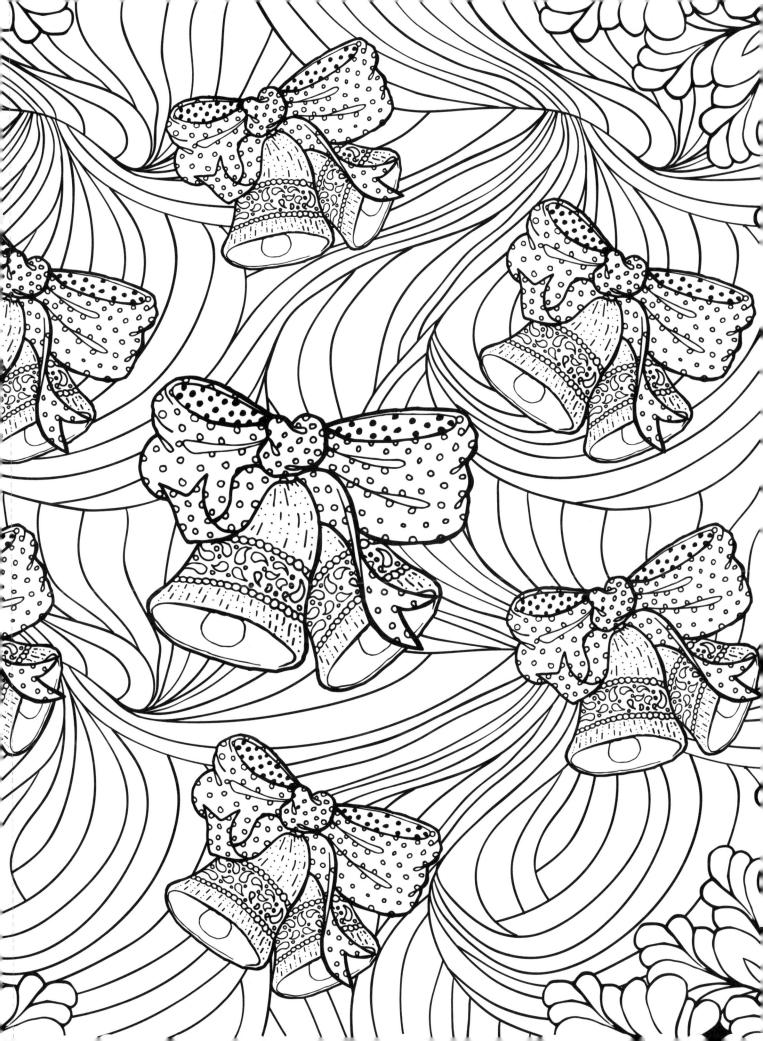

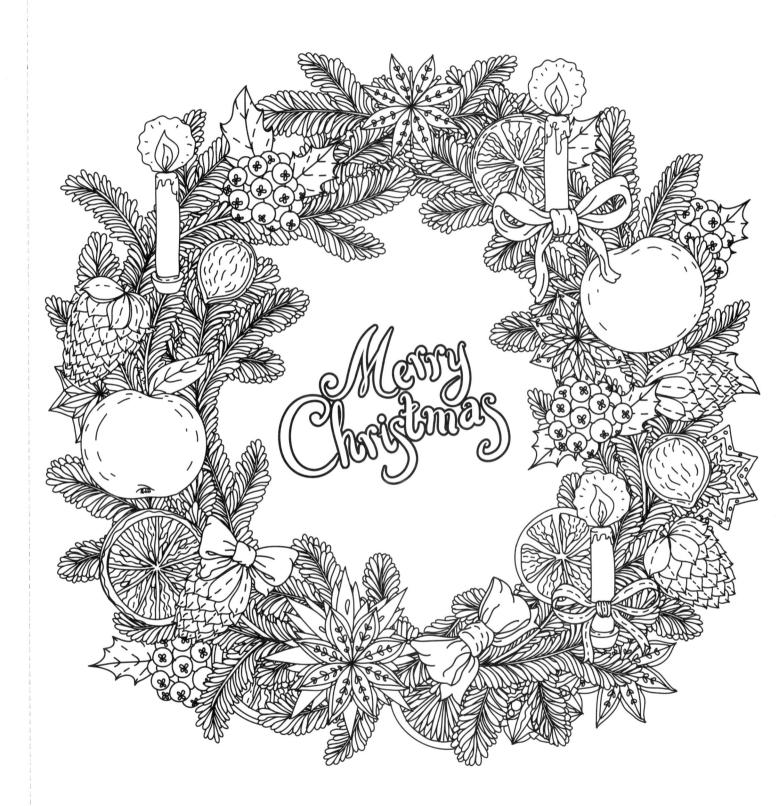

← 4

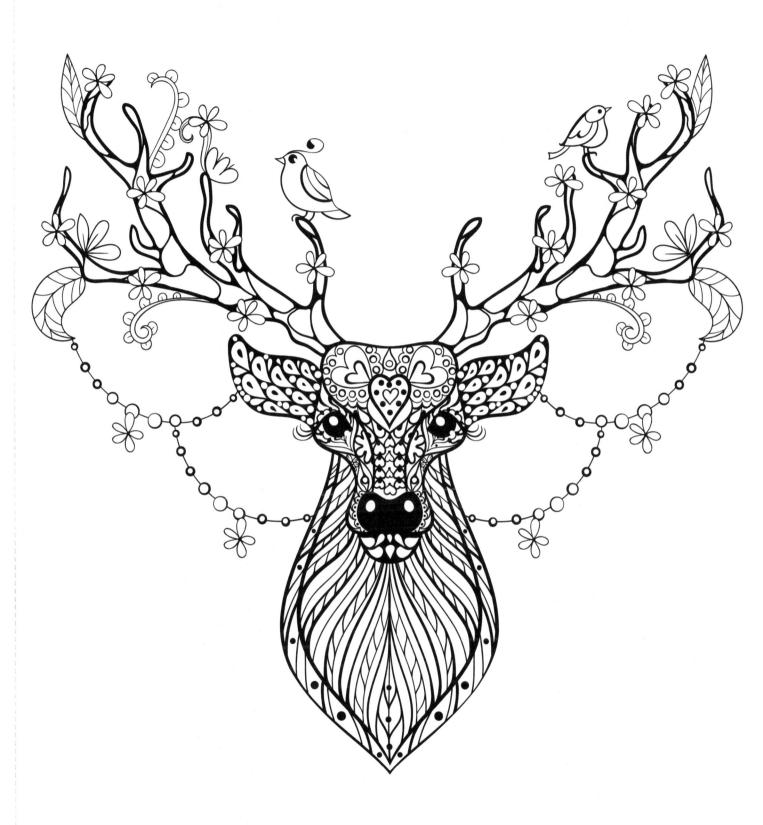

_____ 5

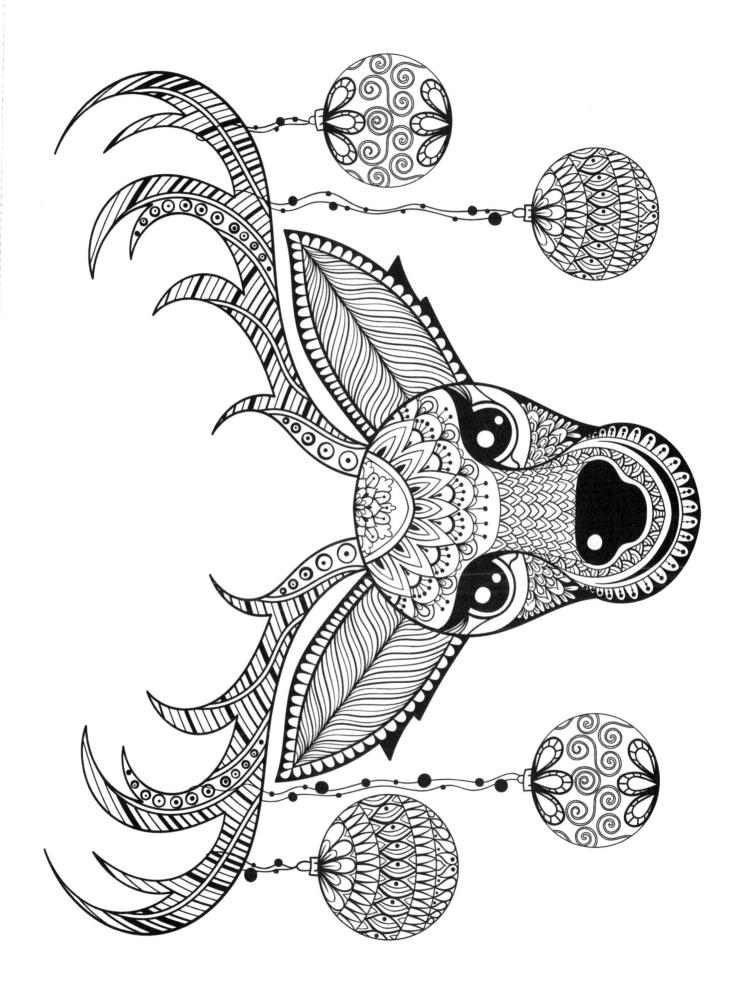

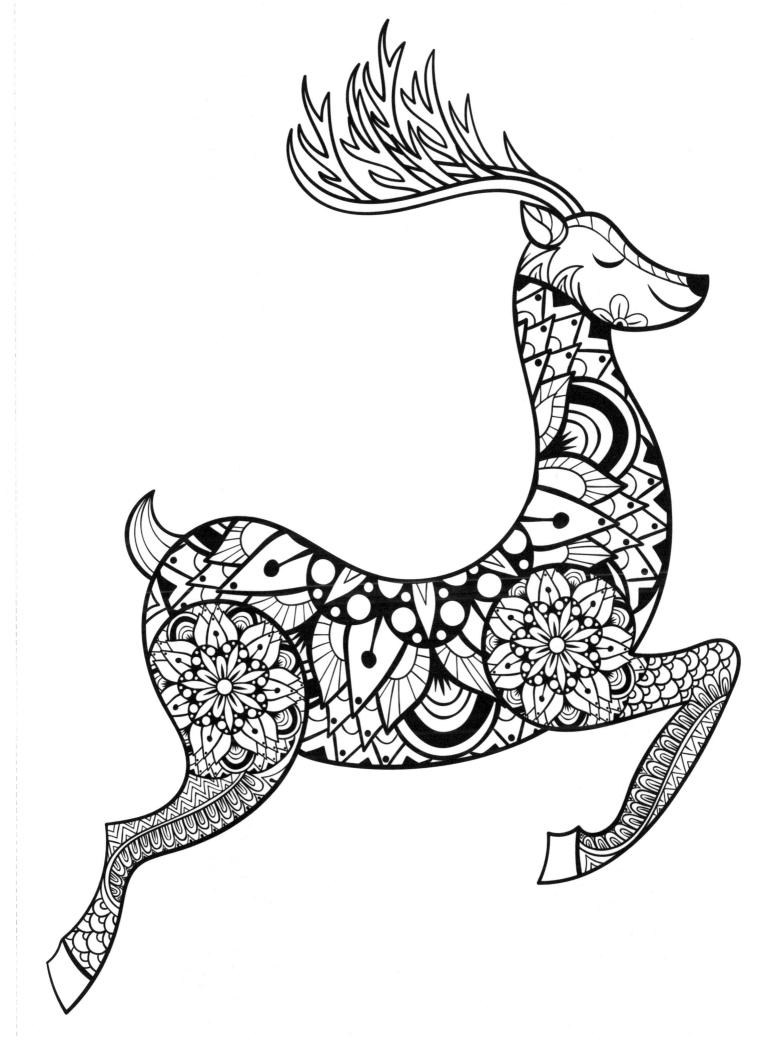

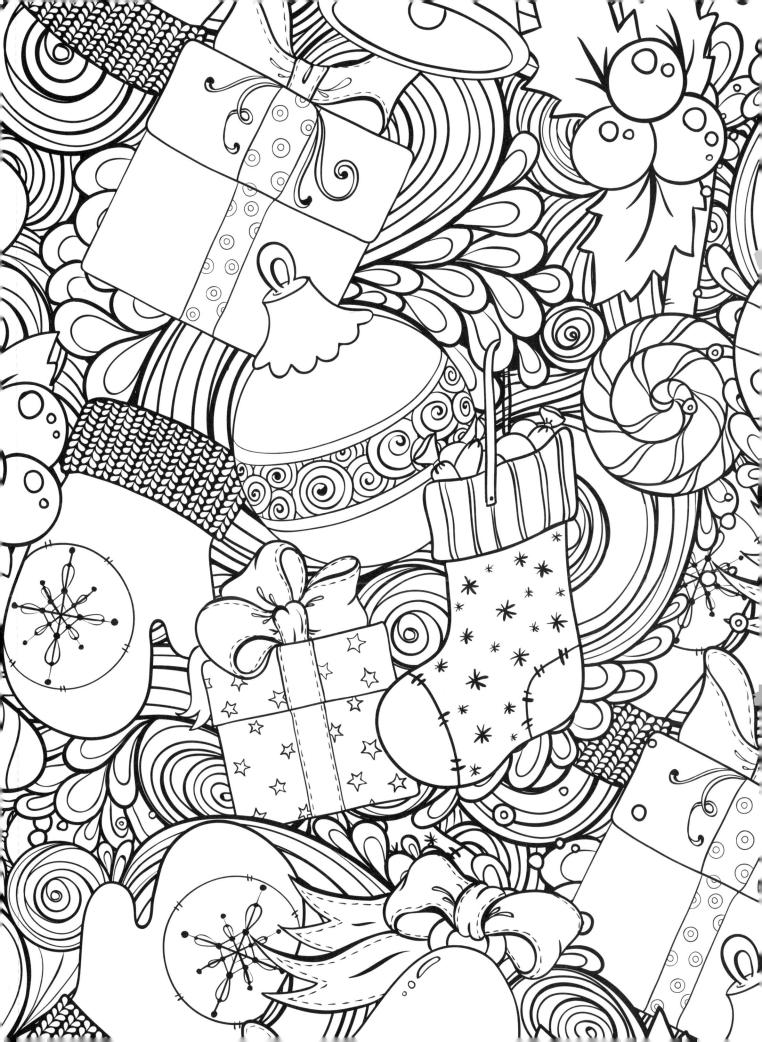

· ·

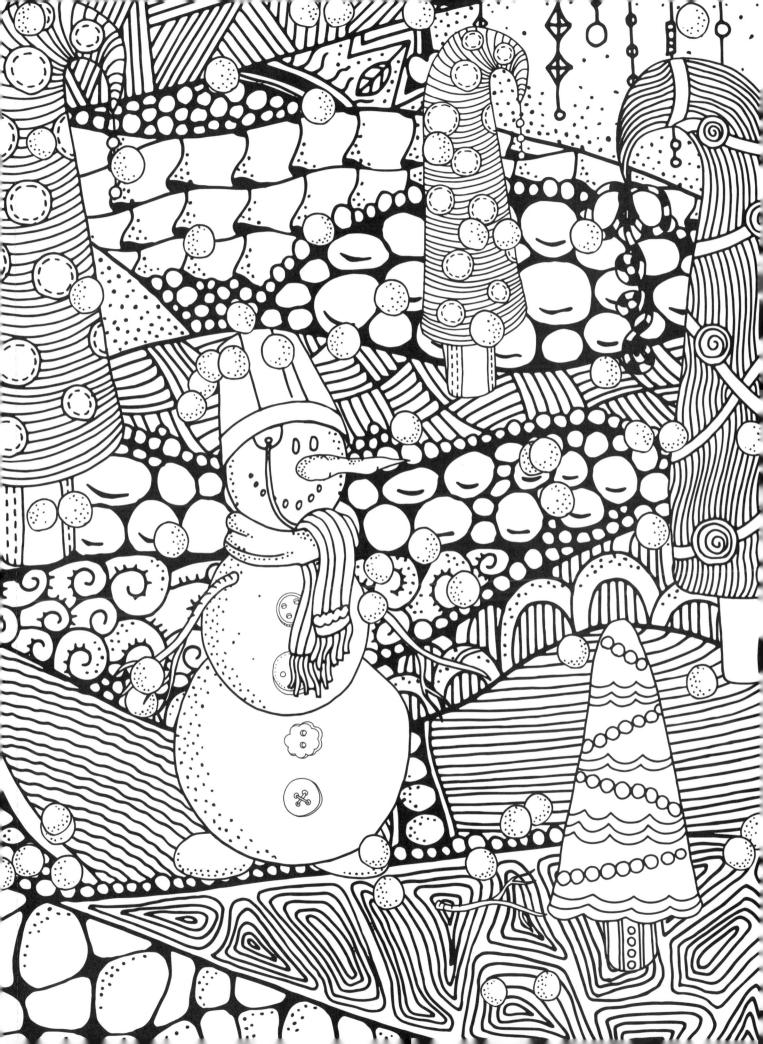

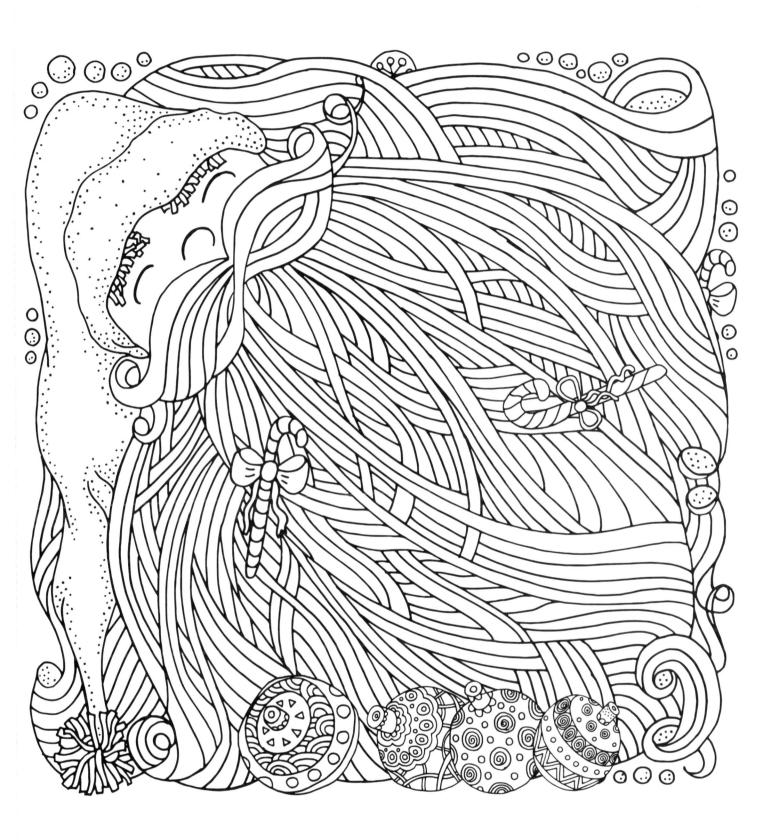

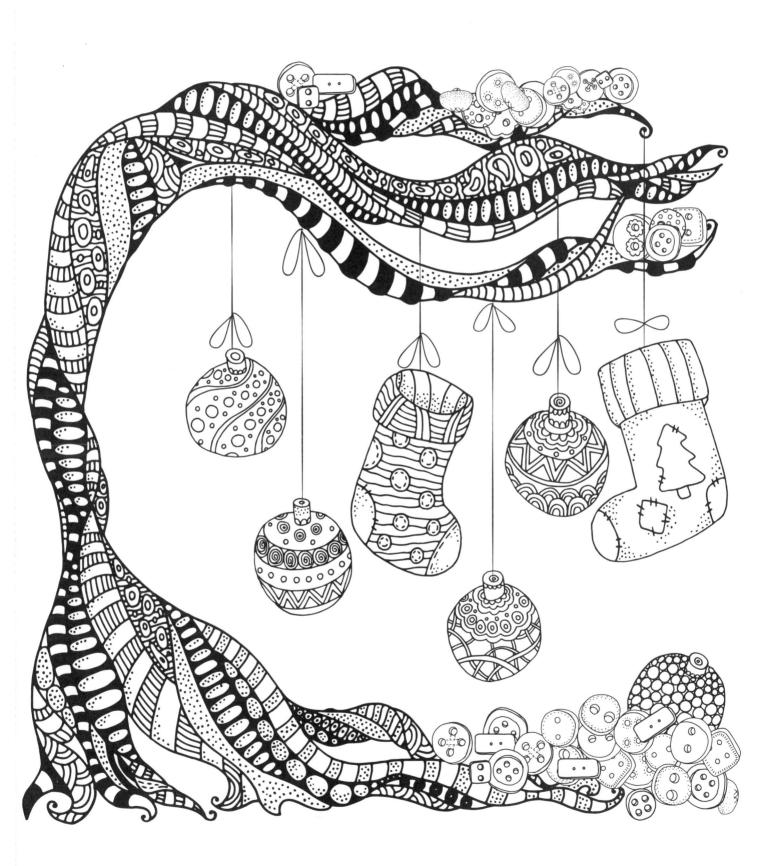

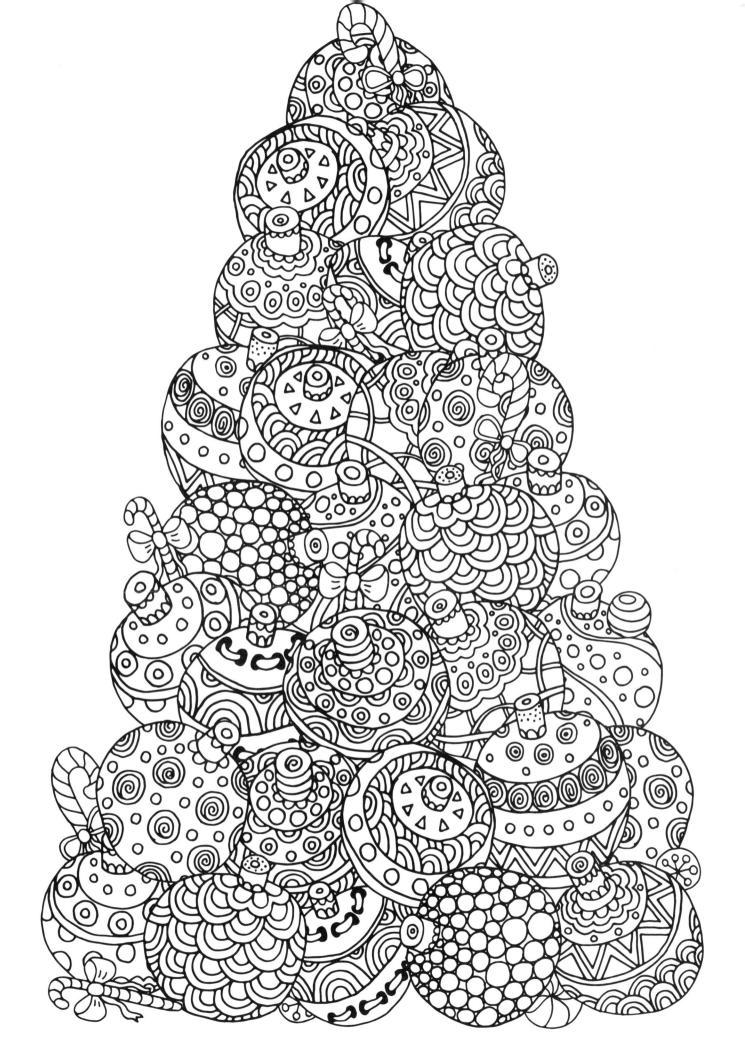

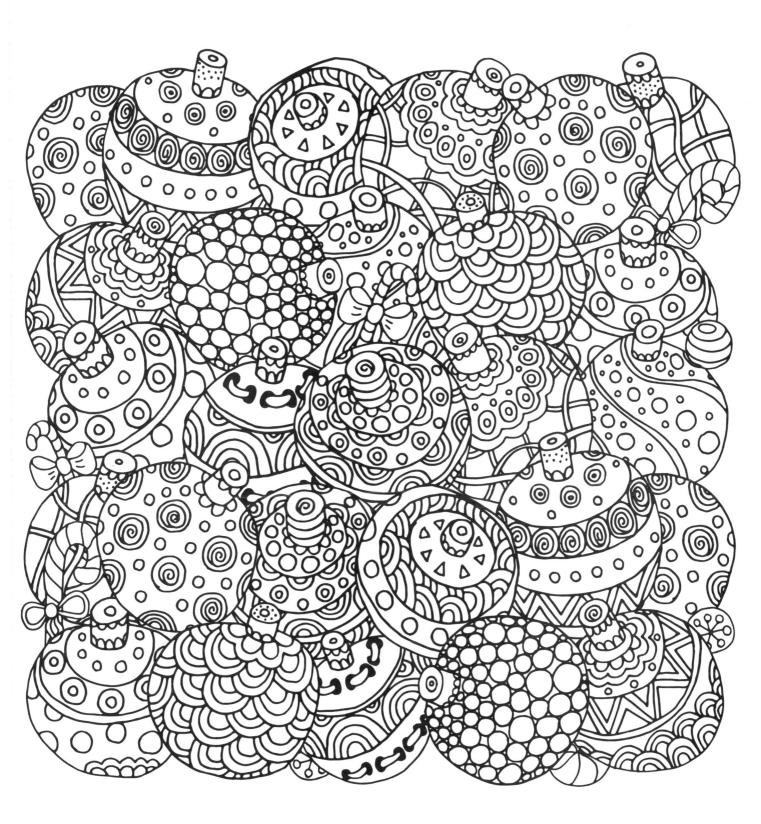

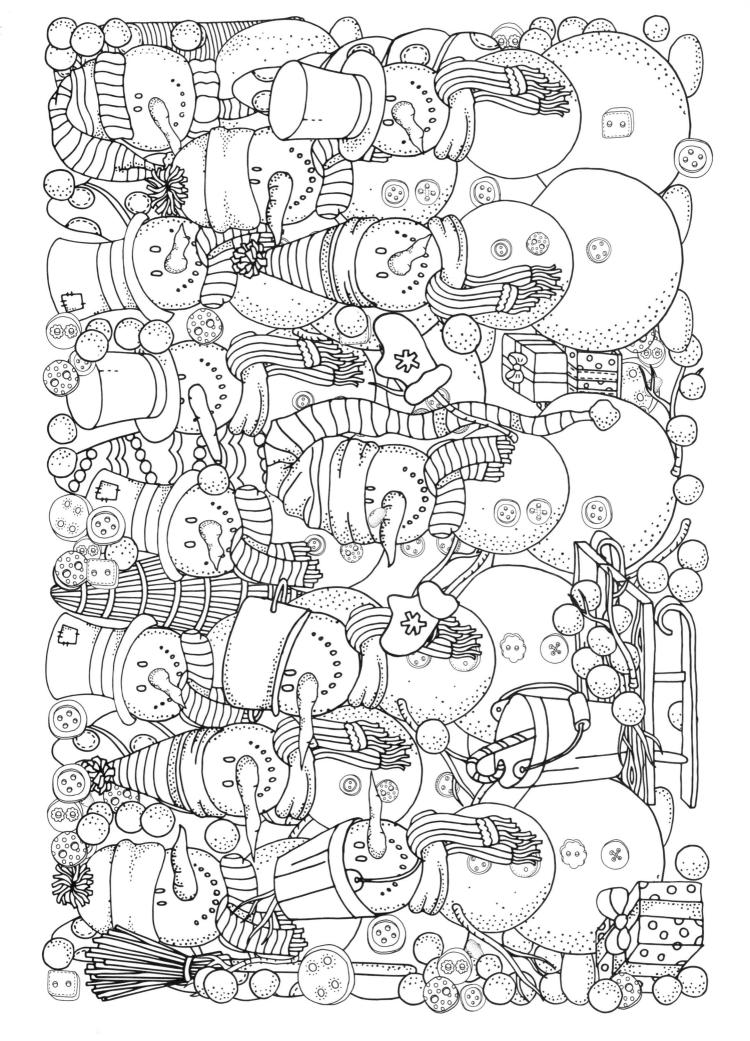

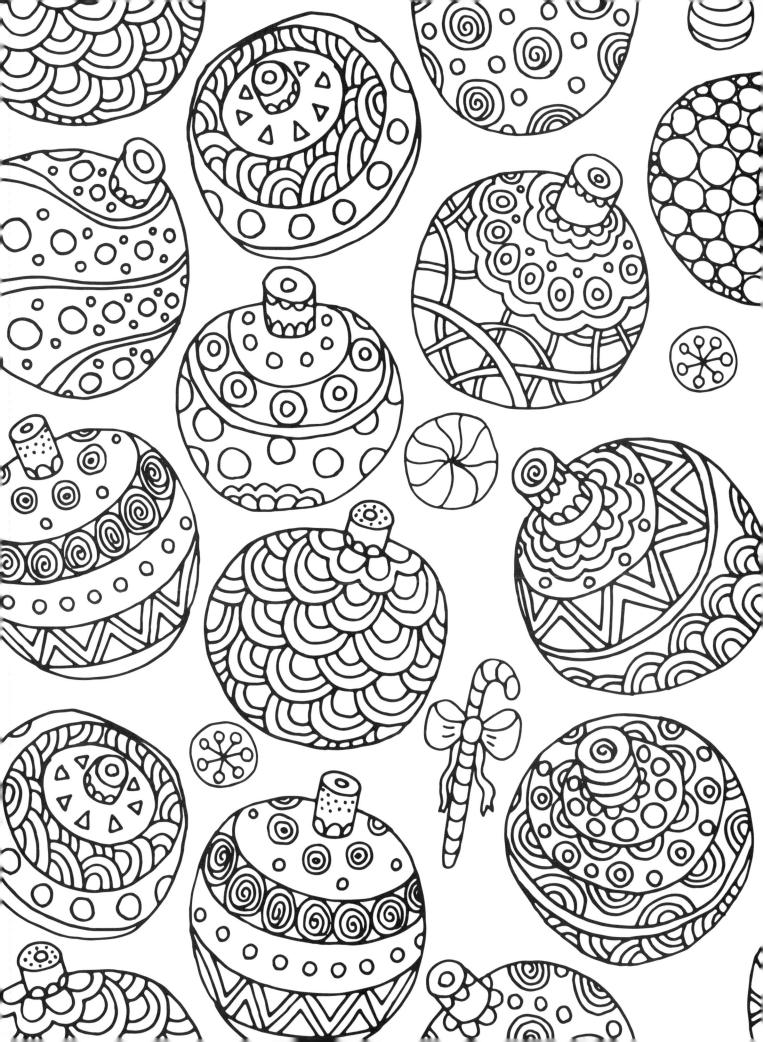

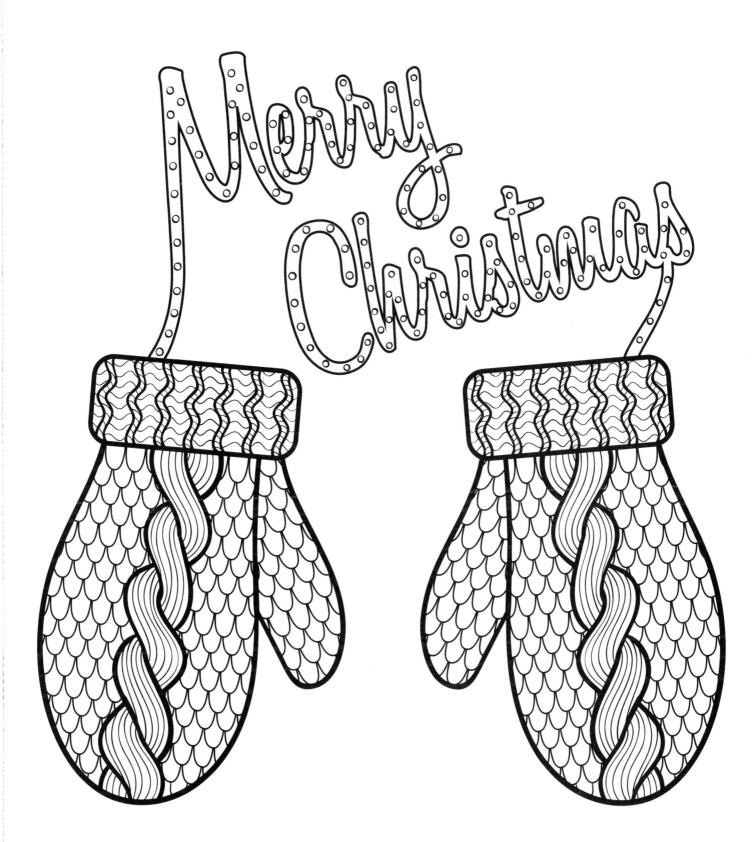

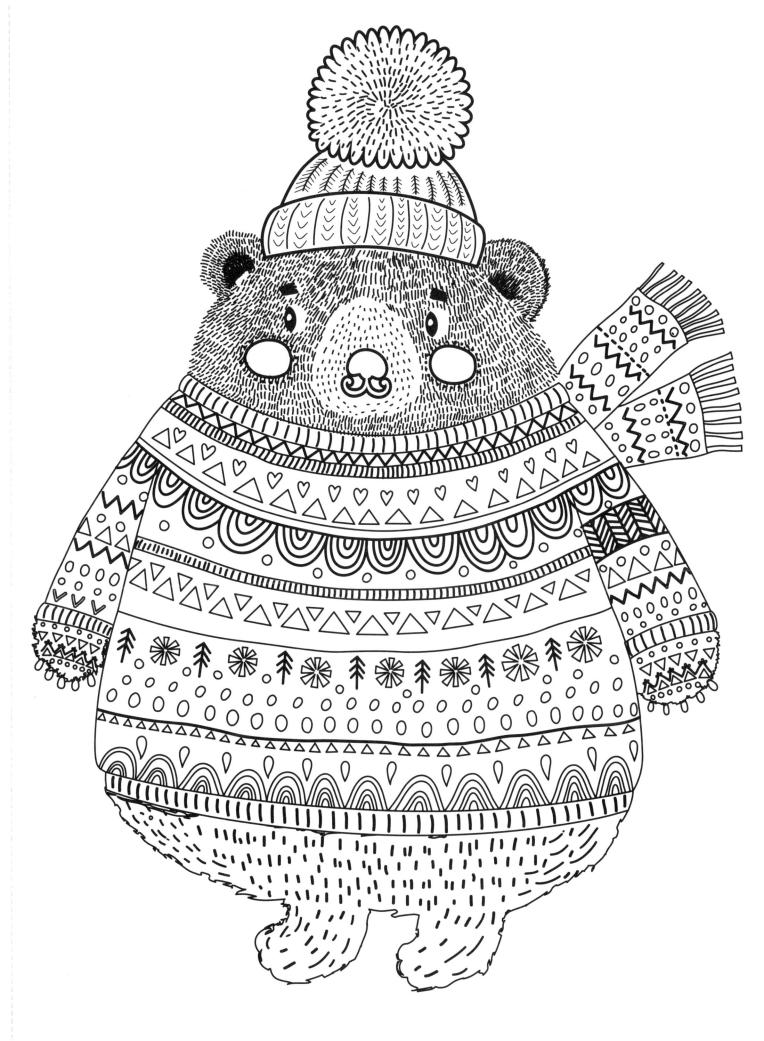

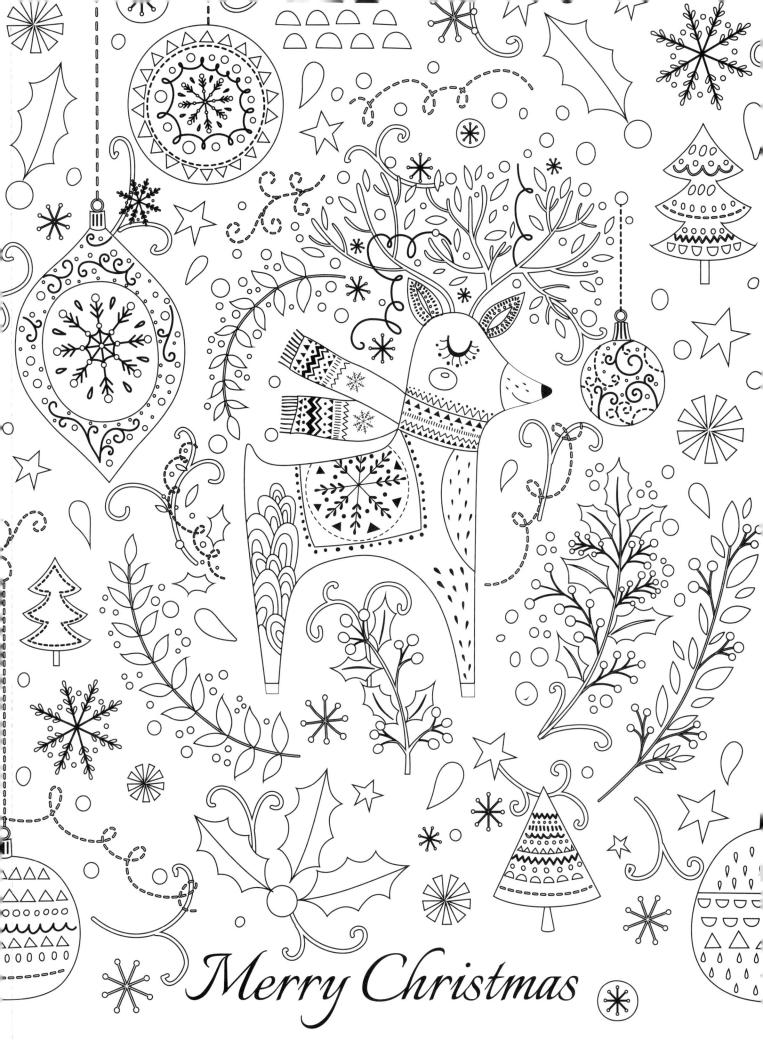

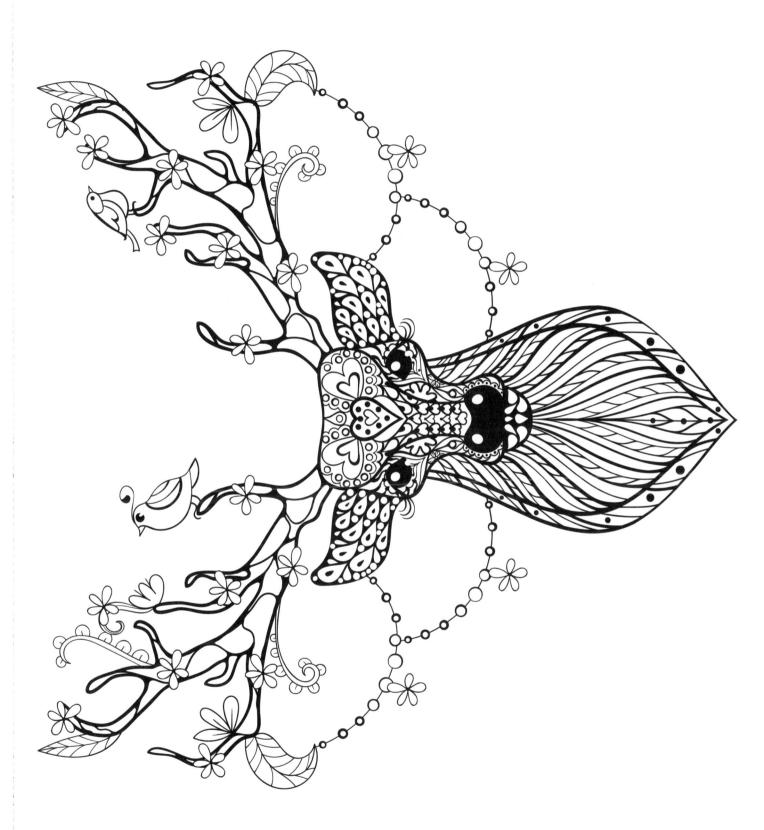

← 19

.

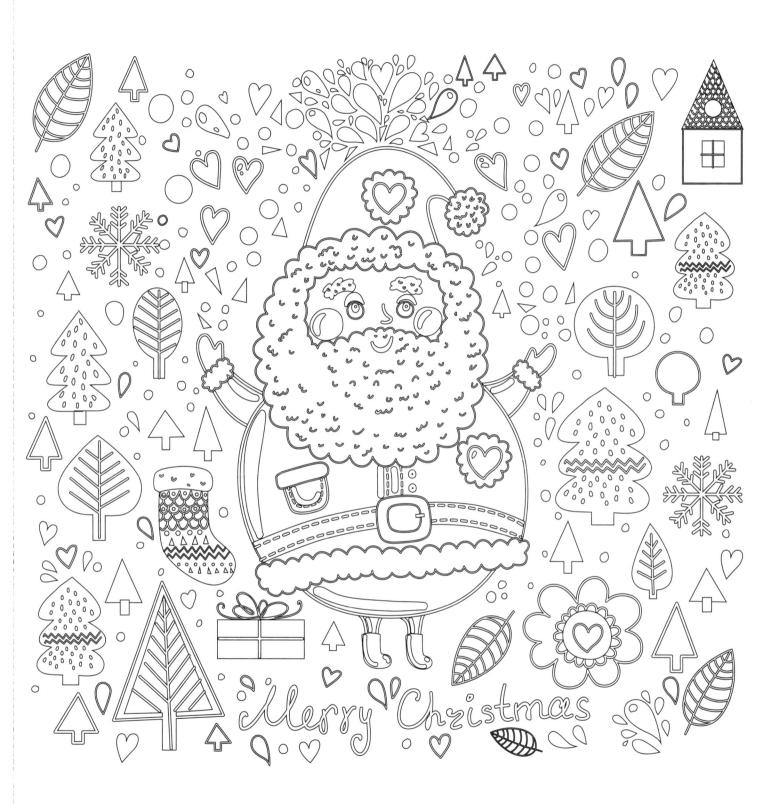

____ 20

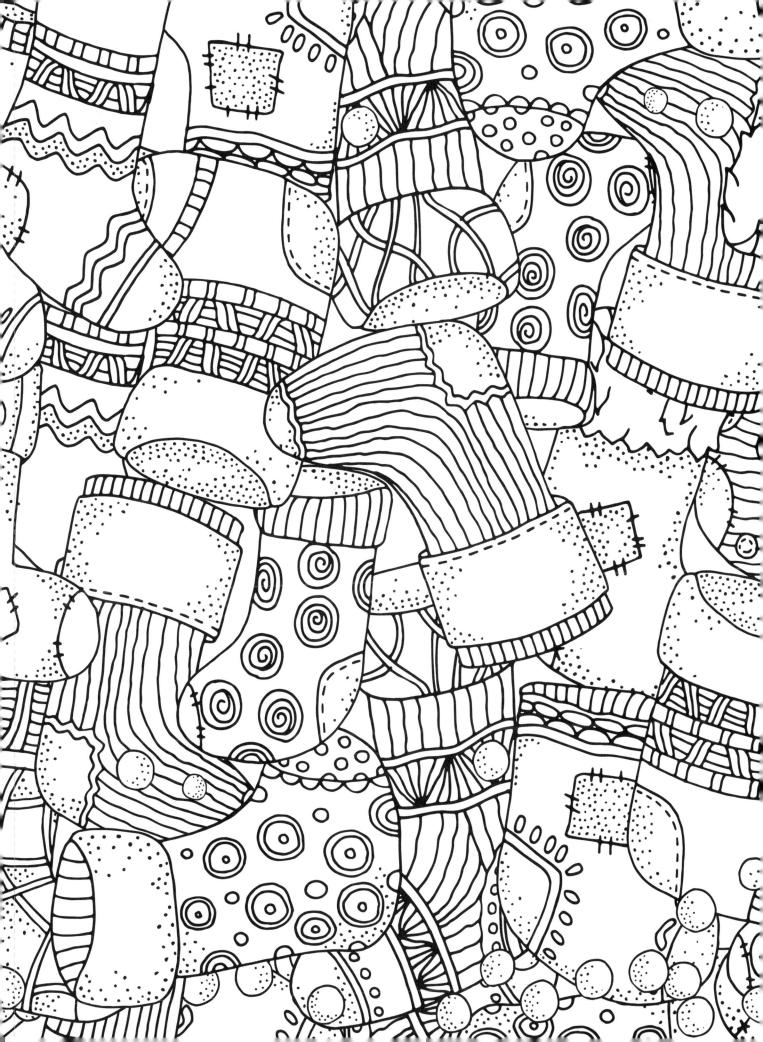

_____ 21

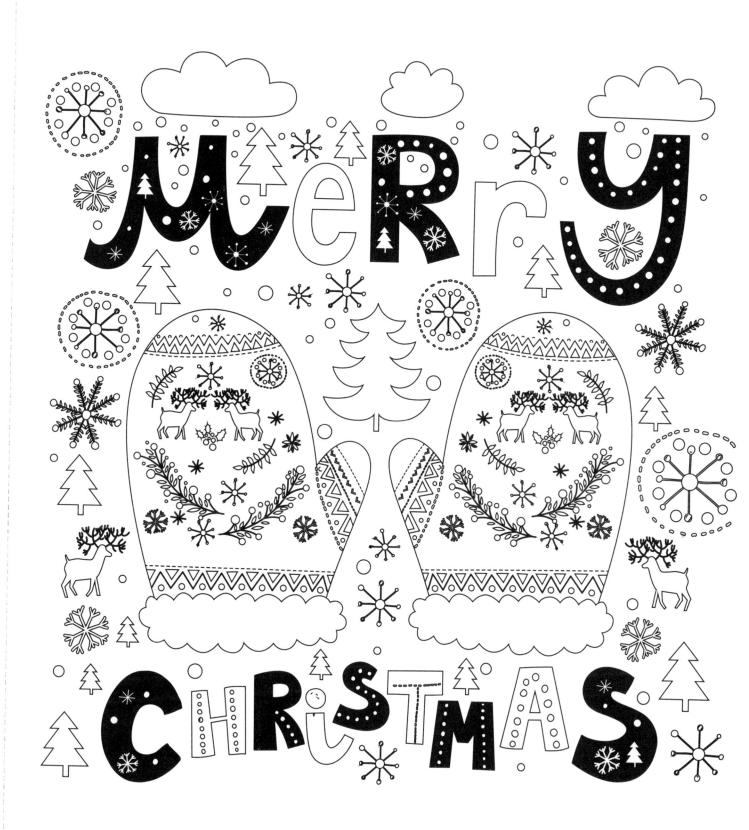

- 22

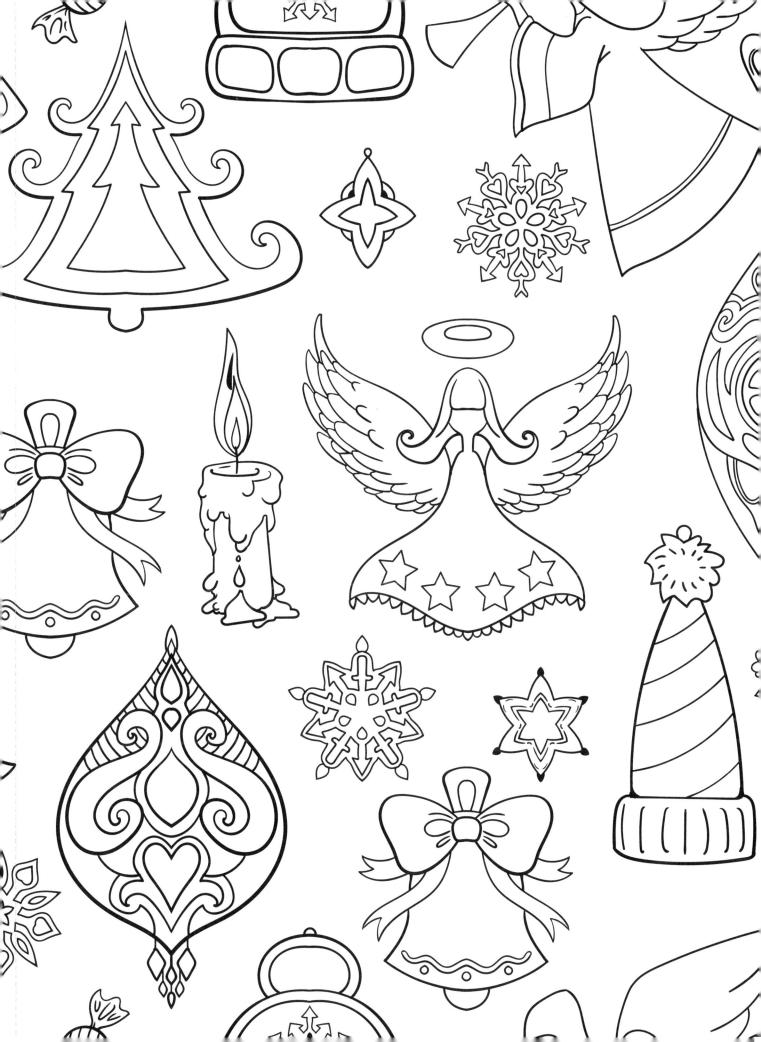

___ 23

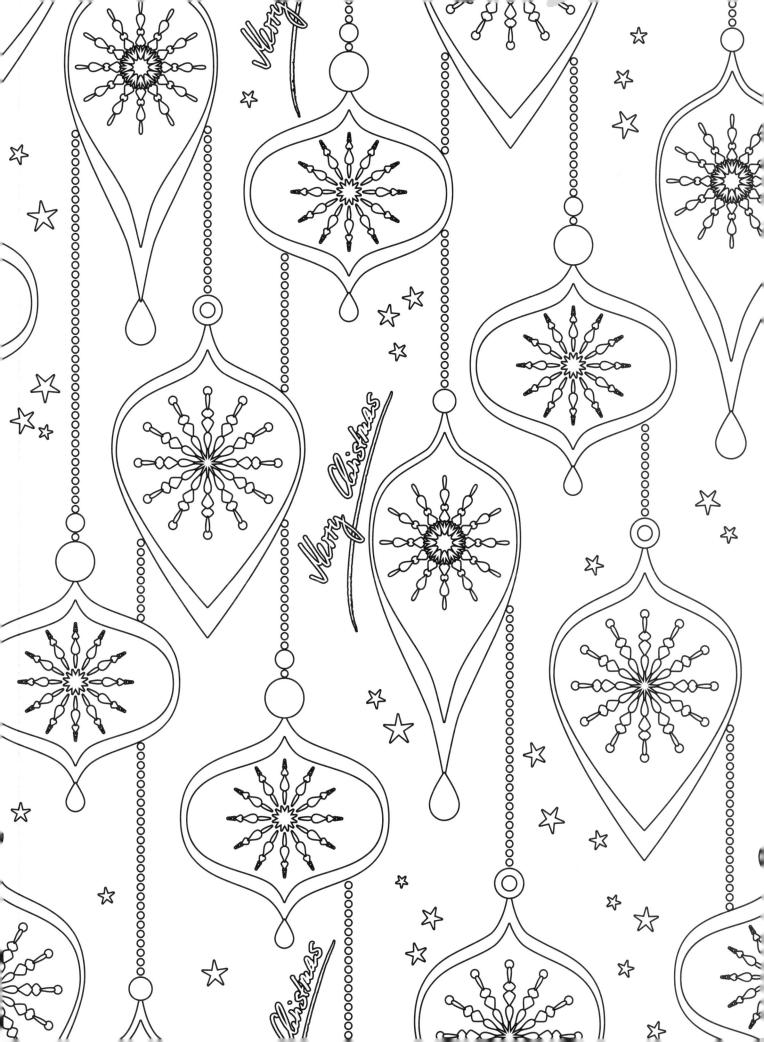

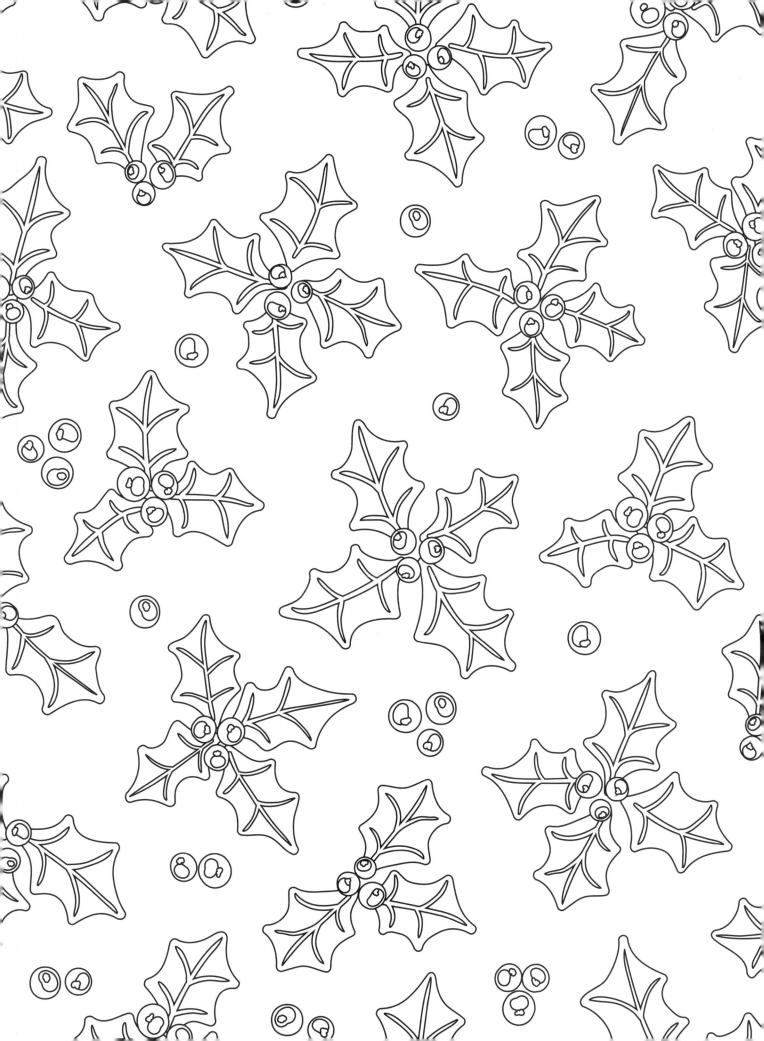

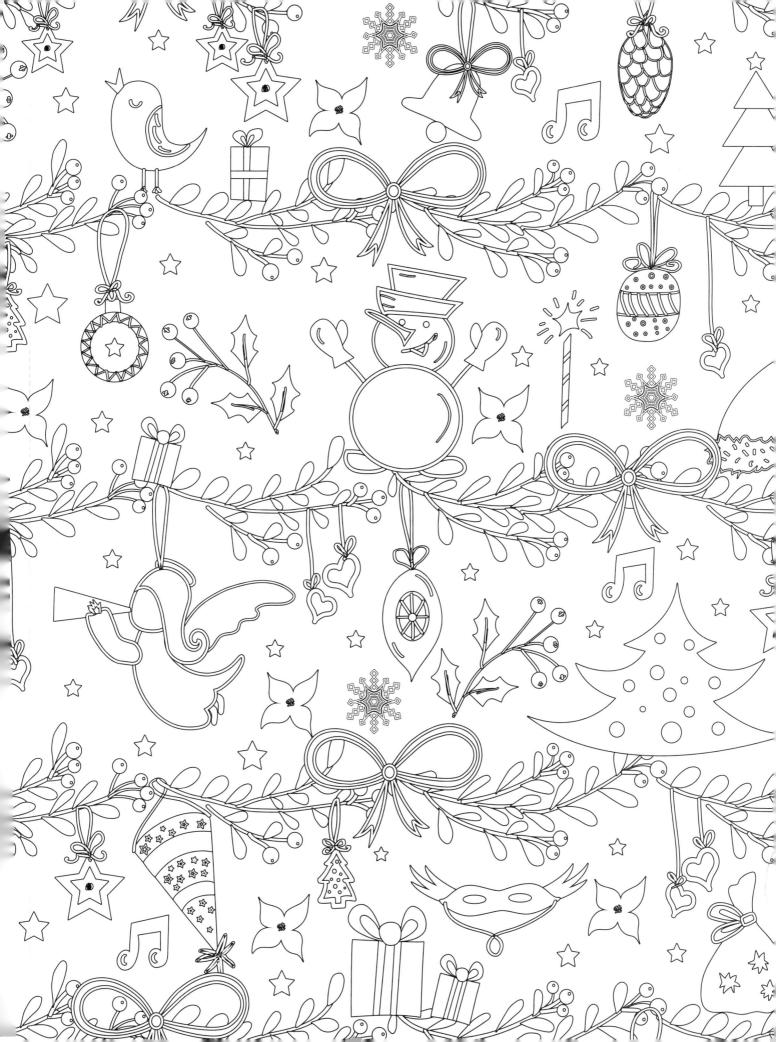

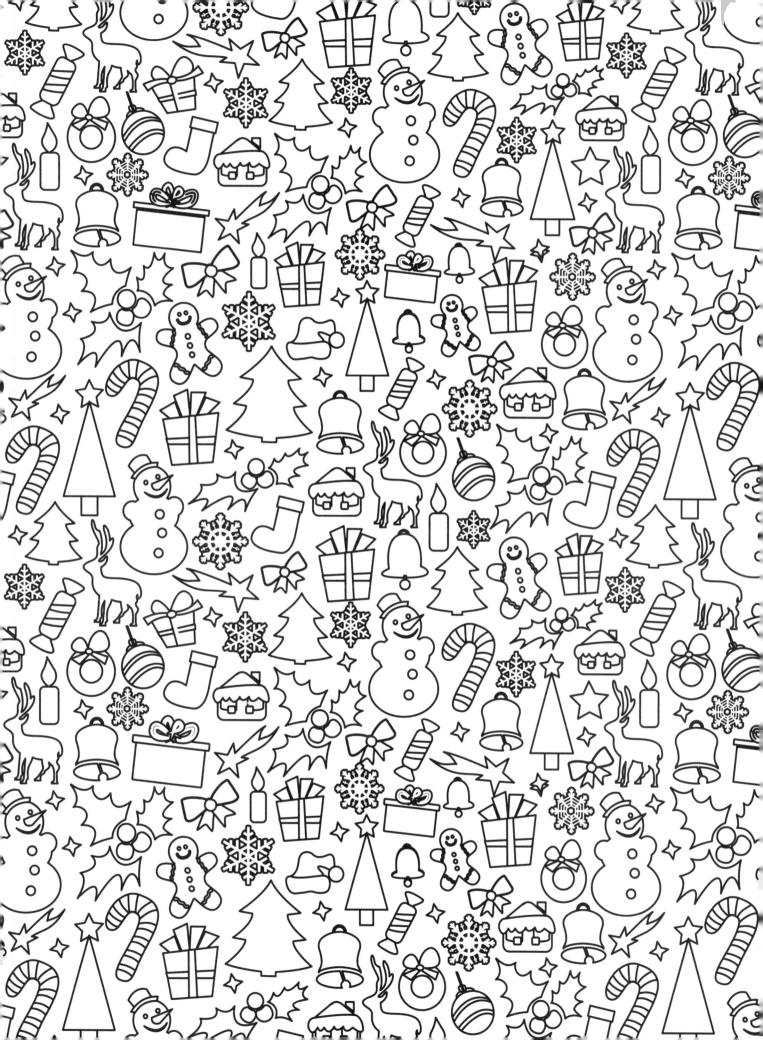

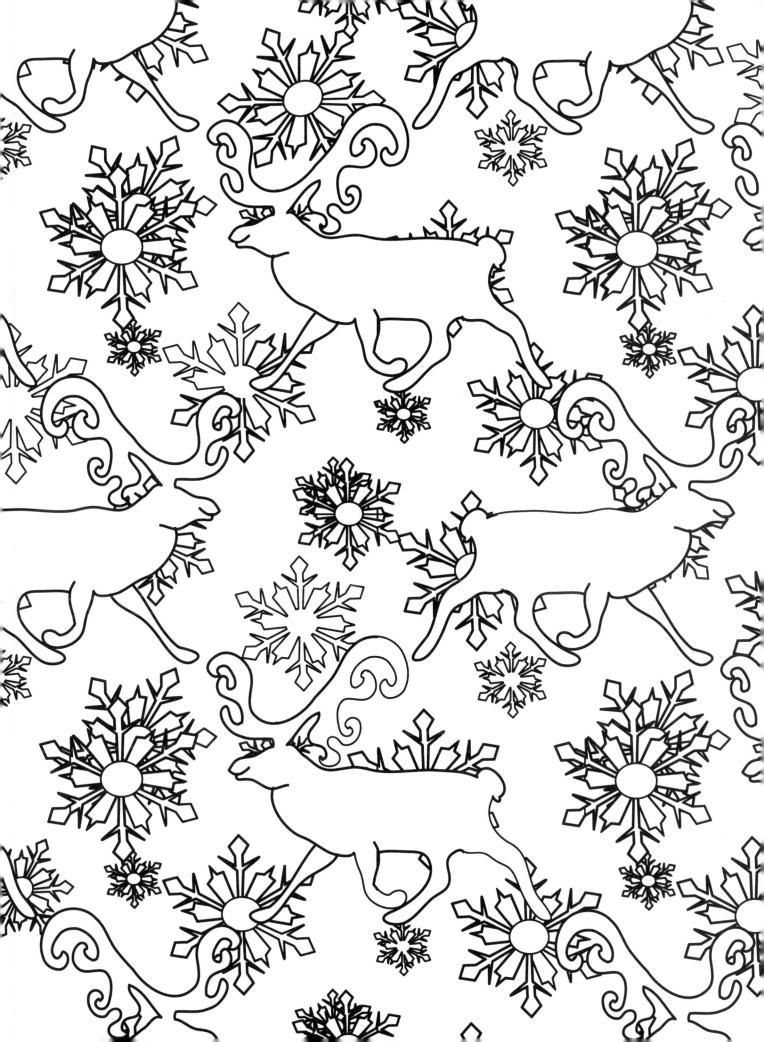

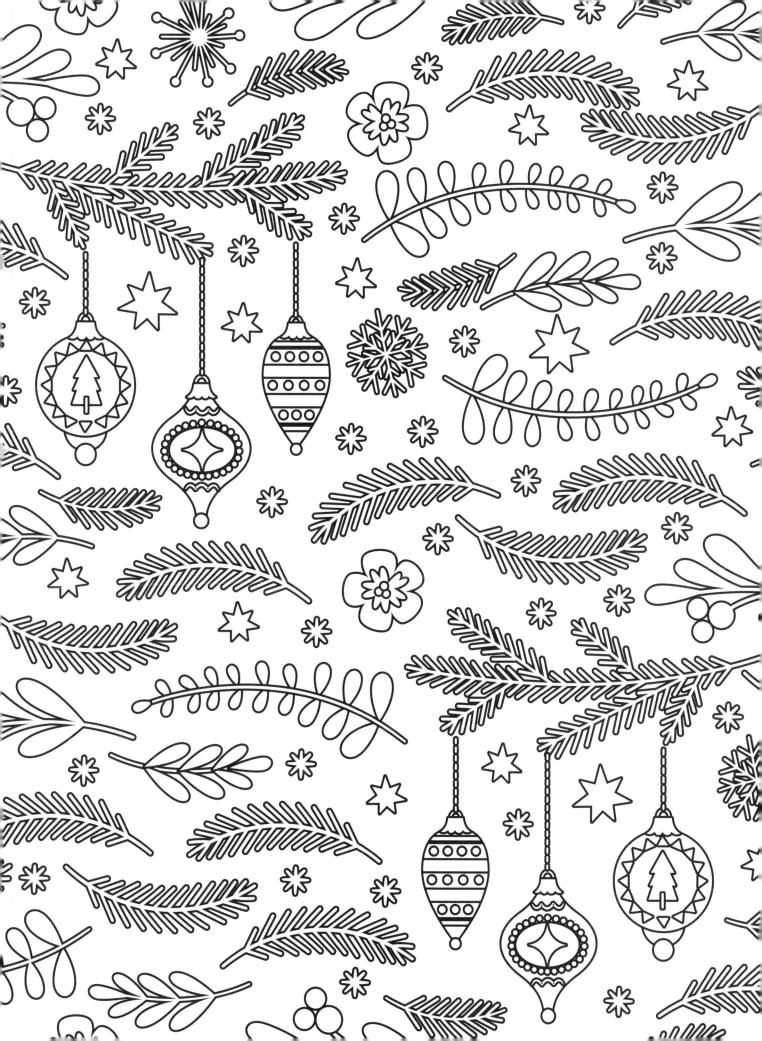

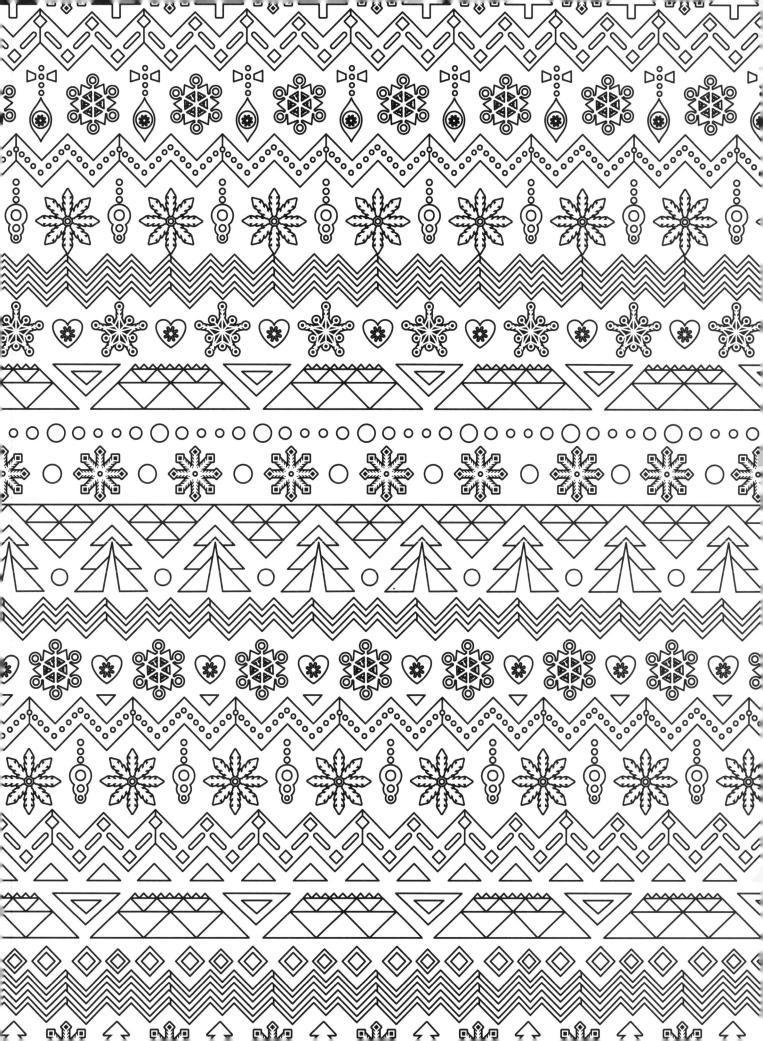